# The Way I See It

## Wood Engravings & Etchings by Peter S Smith

### With an Introduction by Calvin Seerveld

PiQUANT
editions

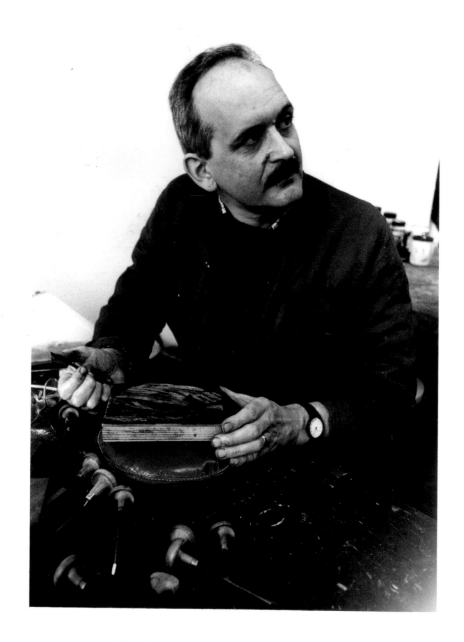

Peter Smith engraving at the Wimbledon School of Art, 1992
(Photo by Simon Burder)

## For Carol Ann

*By means of the iconic, artists express their view of reality and show their understanding of the structure of reality. They see what they know and bring this into their paintings. ... They always give us more than the facts, more than the eye can see.*

Hans Rookmaaker
Lecture 'The Hermeneutics of Art' (1974) in
*The Complete Works of Hans Rookmaaker* 6, p249

I came to know both Hans Rookmaaker and Calvin Seerveld during my art school days in the late 1960s. The way they see things has been part of my cultural matrix ever since. I am particularly pleased that Calvin Seerveld has agreed to write the introductory essay to this book.

Printmaking takes its place alongside my painting and drawing in an ongoing conversation between these ways of working. *The way I see it* is about the way images are made as well as about what is depicted. This selection of prints consists of black-and-white images, most of which are reproduced in full size to enable the mark making to be seen at the right scale. They are arranged chronologically to reflect my changing interests in print process and subject matter. Most date from the period 1972–92.

I wish to express my sincere thanks to Pieter and Elria Kwant at Piquant Editions for commissioning this book and for their constant encouragement.

Peter S Smith

Richmond upon Thames, 2006

# No Endangered Species

## An Introduction by Calvin Seerveld[1]

Box wood is hard to come by these days. The very hard, fine-grained wood of the box tree (*Buxus sempervirens*) is the best for wood engraving. The engraver cuts into the stubborn end grain of a small piece of carefully dried, polished box wood slowly, patiently, with a burin, so that when inked the cut-away block can be pressed to print a relief image on quality paper.

What is the sense of making wood engravings in our day of fast-paced cultural excitement replete with utensils industrially planned for obsolescence?

### A Roundabout Introduction

Once upon a time women were important (c.1250–1550) in commissioning and in receiving what has come to be called Book of Hours (*Horae*) in the Western world.

The Book of Hours were hand-written texts of biblical Psalms and prayers in Latin, especially prayers to the Virgin Mary, inscribed on parchment. The manuscript pages were bound together as a book, which monks and priests used, but also literate, aristocratic women of piety could request or receive as a bridal gift. So these textual prompts for daily prayer at different hours of the day and night extended a regimen of faith exercises to a lay readership. A Book of Hours was like having in reserve a little 'church activity' at home in your personal quarters, or a kind of 'Gideon Bible' for devotions while undergoing the rigours of travel.

These standardized prayers on precious parchment were 'illuminated' by teams of well-paid artisans. The fine calligraphic text was complemented by miniature, once-off paintings of the Annunciation to Mary, for example, or a scene from the biblical story of David and Bathsheba, the Crucifixion of Christ, with a tiny portrait of the patron, or Saint Jerome flagellating himself in penance. Other master craftsmen and their workshops were engaged to decorate the page with borders of fantastical animals, fruits, plant tendrils or colourful, purely geometric designs. The final sumptuous product was usually magnificent.

By the 1400s handmade Books of Hours were prized treasures, often passed down in noble families as heirlooms. The Horae were a tribute to the penitential piety of a wealthy aristocratic laity during times which were a-changing from a medieval, Church-driven culture to a Humanist and Renaissance mix of worldly splendour that seemed to sideline devotion to God and park a person's faith privately, kept for ceremonial occasions only.

---

1    *Calvin Seerveld is an aesthetician and lecturer. He is Senior Member Emeritus of the graduate Institute for Christian Studies in Toronto, Canada, where he was Professor of Philosophical Aesthetics.*

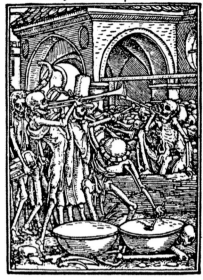

Væ væ væ habitantibus in terra.
APOCALYPSIS VIII
Cuncta in quibus ſpiraculum vitæ eſt, mortua ſunt.
GENESIS VII

Gebeyn aller menſchen.

Malheureux qui uiuez au monde
Touſiours remplis d'aduerſitez,
Pour quelque bien qui uous abonde,
Serez tous de Mort uiſitez.

Hans Holbein the Younger, *Gebeyn aller Menschen*, in *La Danse des Morts* 1538 (Bale: Editions Amerbach 1946)

The historic Reformation which happened north of the Alps in the 1500s was multi-faceted, affecting the power position of the institutional Church in society and the role which governing princes came to play in the professed faith of a nation (*cuius regio eius religio*). The general movement for Reformation also stimulated the democratizing of artistic culture.

Clergy had earlier affirmed the painted images in Book of Hours as a good aid for women in schooling their piety. Iconoclasm in the Roman catholic Church had largely been laid to rest by Gregory the Great (Pope, 590–604). The concern of Reformational leaders lest sculptural images become idols for the ignorant had the surprising effect of promoting graphic art, because art on paper lost the stigma of being a painting or a three-dimensional image which could itself be adored in devotional prayer.

What was achieved by painted fresco murals of Bible stories and mementos of venerated saints on the walls of Roman catholic Italian churches, and by icons in Greek and Russian Orthodox churches crafted to focus the devout attention of believers into meeting God, now in Protestant Reformation countries was achieved through block books of woodcuts, the *biblia pauperum* for 'poorly' educated preachers.

Albrecht Dürer from Nurenberg (1471–1528), who later in life became deeply convicted by Luther, fashioned already early on (1498) a powerful, dramatic series of 14 woodcut plates to tell not royalty but German burghers, almost like a lay preacher, the fascinating episodes of the Newer Testament Apocalypse of John. Lucas Cranach (1472–1553), Wittenburg court painter for Frederick the Wise, not only painted his Mannerist nudes of demure lasciviousness with names like 'Eve' and 'Venus' but did many portraits of Luther, replicated and multiplied in copper engravings and in woodcuts and distributed like broadsheets so that his profile became well recognized.

The invention of movable type had led to the folio-printed Bible of Johann Gutenberg (c.1394–1465) in 1456—Cranach has 21 illustrations in Luther's *Neues Testament Deutzsch* (1522). And artist Hans Holbein the Younger (originally from Augsburg, 1498–1543, died in London) drew 41 scenes on wood blocks (1523–26) which taught that death is no respecter of professions but comes calling on pope and farmer, children as well as the aged. Holbein's drawings were meticulously cut into the wood by Hans Lützelburger, an expert craftsman specialist trained to reproduce exactly what the artist wanted; and the lot was finally published as a kind of biblical catechism, an Emblem book, *La Danse des Morts*, in Lyons, 1538.

'Emblems' were an instructional composite of (1) visual representation of an idea, with (2) a motto or Bible text, normally in Latin, and (3) a short verse explaining the point in the vernacular language. These well-crafted devotional aids, dating from the Reformation, were printed booklets duplicated on paper rather than one-for-one illuminated manuscripts on parchment. So Emblem books served a wider, more commoner public and facilitated literacy.

## Touching Down In English Wood Engraving History

Painter William Hogarth (1697–1764) was never fully accepted by the English gentry of his day, and so he took to the streets, one could say, with his engraved etchings that told stories in pictures with a moral point. Hogarth's graphic art followed up John Bunyan's *Pilgrim's Progress* (1678) with his *Harlot's Progress* (1732) and *Rake's Progress* (1735), and a later series on the *Industry and Idleness* (1747) of apprentices. These combined the Emblem book tradition and picaresque story line to report in empirical detail and to caricature the sometimes hypocritical middle-class commercial ambition. Hogarth's heavily subscribed early engraved etchings on copper were so popular they were pirated, copied and sold cheaply without giving him credit or any recompense. So Hogarth initiated in Parliament 'the Hogarth Act' in 1735 which protected engravers' rights to their designs and products for 14 years.

Another gifted English artist, the poet-drawing engraver William Blake (1757–1827), challenged the smug Enlightenment mentality, which was busy supplanting the christian faith, and the 'religious wars' (Seven Years War, 1756–63) with a tolerant Deist Rationalism: *'Mock on, mock on, Voltaire! Rousseau! / Mock on, mock on, `tis all in vain! / You throw the sand against the wind, / And the wind blows it back again.'* Blake's 'illuminated printing', as he called it, married compelling linear, hand-coloured drawings and poetic texts. Words and flamboyant image were engraved and printed on the same page and looked almost like pictorial hieroglyphics. Blake's visionary Swedenborgian imagination and driving restless Romantic spirit, however, kept his brilliant eccentric artwork, and even his few late wood engravings, prized by the few, beyond the pale of most proper folk.

Thomas Bewick (1753–1828), who set the standard for wood engraving in England (using the end grain of box wood) as distinct from woodcut (using the plank side grain of softer woods), fits snug into the sunny-side-up Rationalistic sensibility of the day and the appetite for encyclopedic knowledge of 'natural history'. Bewick's *History of Quadrupeds* (1785–90), followed by *History of British Birds* (1797–1804),

depicted animals he had spent time observing (whenever possible) and drawing in their habitats. He was not reproducing anything, but was 'life drawing' animals, with respect for their several natures, engraving with precise exactness the over confident strut of the starling and the wary, alert early bird robin in a snow-covered field near a still frozen pond of water. Thomas Bewick was rigorously rural, an industrious denizen of Newcastle, whose tail-piece vignettes (to fill out a page of print) have the gentle, puckish humour and wisdom of a sharp-sighted, shrewd country sage.

Periodicals like *Punch* (founded 1841) and *Illustrated London News* (began publication 1842), which served the rapidly increasing literate public, hired teams of wood engravers to illustrate their journals. The *Christian Herald*, as well as the cheap 'penny dreadful' chapbooks hawked on the street, the elaborate catalogues of the Coalbrookdale Ironfoundry and Edward Lear's (1812–88) *Nonsense Books* all needed illustrations to catch the reader's eye and sell the traders' wares. Wood engravers could earn

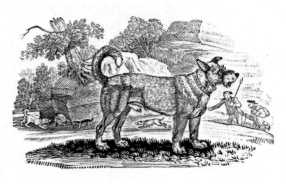

Thomas Bewick, *The Terrior*, Woodcut, 1785–90, 70mm x 40mm (Bewick Society)

a living with their engraving craft! even if it sometimes became pressured commercial routine and they with their apprentices were nicknamed 'woodpeckers'.

The literary PreRaphaelite painterly artists Millais, Holman Hunt and Dante Gabriel Rossetti designed narrative illustrations, for example, for an edition of Tennyson's poems (Moxon edition, 1855–57), and left the actual engraving to the expert Dalziel brothers who were expected to reproduce the prescribed design without deviation. Instead of considering such a partnership co-operative artistry, the Royal Academy of Art (Painters and Sculptors) considered the lowly wood engravers ineligible to be artists. Even someone like Timothy Cole (1852–1931), who made fantastically accurate facsimiles of famous paintings for the American Scribners publisher, was discounted as merely a 'craftsman'.

Those were fighting words for William Morris (1834–96) who, with John Ruskin (1819–1900), faced the quandary that photo-mechanical processes and the Capitalistic assembly line in force were indeed both downgrading wood engraver apprentices into hacks of slavish detail and making them expendable. With Utopian Socialist fervour Morris instigated Walter Crane (1845–1915), architect William Richard Lethaby (1857–1931) and others in 'the Arts and Crafts movement' to raise the status, quality and pay of manual artisans. Unfortunately Morris's visionary 'medieval' and 'Icelandic' norms suffered from a domesticated Neo-Idealist spirit sometimes called 'Victorian'. The Kelmscott Press which Morris set up in Hammersmith (1891) to fuse typography, text and wood-engraved image into a hand-printed and bound illustrated Book Beautiful (*Gesamtkunstwerk*) constricted wood engraving more toward decorative borders. An item too luxurious for Industrial day labourers to own, it had an immediate out-of-date feel and look.

The significant historical upshot, however, of William Morris's cultural effort was: (1) the differentiation of wood engraving from being an ancillary complement to art into becoming recognized as artistry itself—the gallery of Dutch E J van Wisselinge & Co showed 71 wood engravings framed on gallery walls in a London exhibit on 1 December 1898. And (2) other private (non-commercial) presses like Morris's Kelmscott Press struggled into existence to publish fine limited editions of books featuring prints of wood engravings as artworks.

At the Central School of Arts and Crafts in Southampton Row, London, built by Lethaby, a calligrapher Edward Johnstone (1872–1944) taught in 1899 both Noel Rooke (1881–1953) and Eric Gill (1882–1940). Rooke later taught wood engraving at the same school (beginning 1912) to Robert Gibbings (1889–1953), John Farleigh (1900–65) and others, emphasizing that a wood engraving is only a bona fide, original work of art if the engraver has self-designed and incised the block, using the graver tools to make marks in the distorting end grain proper to the graver's instruments.

And it was this nucleus group who in 1920 organized the Society of Wood Engravers, along with Lucien Pissarro (1863–1944), Gwendolyn Raverat (1885–1957), John Nash (1893–1977), Philip Hagreen (1890–1988), Sidney Lee (1866–1940), Edward Dickey (1894–1977), and Edward Gordon Craig (1872–1966). The Society of Wood Engravers was formed to hold an annual exhibit in order to give wood engraving its own niche as an independent graphic art.

Stone engraver and letter cutter Eric Gill was one of the more flamboyant members. Son of a Non-conformist minister, he became Roman Catholic in 1913 and formed a sort of Catholic Guild of wood engravers in Ditchling to expose economic evils in society. Eric Gill also illustrated many books for the private Golden Cockerel Press run by Robert Gibbings (from c.1924–33). Gill's wood engraving style has a strong, flawless black line, and is often flagrantly in-your-face erotic, with a brazen coldness similar to the black-and-white art nouveau drawings of Audrey Beardsley.

John Farleigh's truly interactive development with George Bernard Shaw to illustrate Shaw's fable of *The Adventures of the Black Girl in her Search for God* (1932) demonstrates how illustrations in a book can be striking artistry and not just an explanatory device or decorative sideshow: Shaw even agreed to write 20 extra lines of text to accommodate the page placement of one of Farleigh's prints! Farleigh's wood engravings visually enhance Shaw's verbal meaning. The finely engraved images allusively clarify and epitomize what Shaw narrates. Just as a good literary translation almost imperceptibly highlights only certain connotative features compressed within the original text of a different language, so Farleigh's taut drawings full of vitality subtly translate Shaw's English text into captivating figures. The unaffected naked virginity of the black girl amid the clothed vulgarity and self-deceit of her disputants reverberates with and reinforces Shaw's risqué irony.

Sculptor Gertrude Hermes's (1901–83) wood engravings breathe a planned experimental spirit. Whether it be the undulating curves of *Waterlilies* (1930), a panoramic gaze upon impassive *Stonehenge* (1963) or the penetrating exploration of human relationships, there is an intense fixity to the artwork. The object depicted is brought frontally close to the picture frame excluding any landscape background. The nervous Cubist style exploration of *Two People* (1933) has a troubled, unfinished struggle to its form. There are usually murky undercurrents of gravity and mystery in Hermes's engraved prints that bespeak unsettled life in our current world society.

The vicissitudes of the Society of Engravers as generations passed since its inception in 1920, the hardtimes and failure of many private presses in the financial depression of the 1930s, the disruption in the British artworld brought on by World War II (1939–45) and the threat of extinction to xylography by postwar linocut artistry, not to speak of the rise of commercial ready photographic art, all seem to place wood engraving as a species of artwork in jeopardy today.

However, John Farleigh wrote *Graven Image* (1940) and led to setting up the Craft Centre of Great Britain in 1946, which united the Society of Wood Engravers with four other independent arts and crafts societies. The Victoria and Albert Museum held 'The Craftsman's Art' exhibition in 1973, and after Albert Garret (1915–83), who had been president of the Society of Wood Engravers for 16 years, died, Hilary Paynter (b.1943), Kenneth Lindley (b.1928) and George Tute (b.1933) revitalized the Society of Wood Engravers in the 1980s.

These are the circumstances in which the young painter and design instructor Peter S Smith has gradually found his own way. After having his wood engraving work accepted for three years in the annual open exhibit, a requirement for admission, Peter was nominated for membership in the Society by Edwina Ellis in 1986. His most current artwork has been the finishing of a commission by Kingston College, Surrey, for six large paintings showing the neighbouring environs of the college (1995–2005). But wood engraving is not an endangered species in the oeuvre of Peter Smith: this special, difficult artistry in wood fits the man to a T.

## Peter S Smith: A Portrait of a Young Man Becoming an Engraver

To grave the end grain surface of an expensive piece of hard box wood with the cut of a line is as final a judgment as taking a chisel to stone or marble. Copper etchings can be corrected, but carved-away stone or wood is less forgiving of mistakes. Disciplined precision is requisite for wood engraving: steady hands, deliberate marks, a love to be in touch with intractable woody material. And it takes patience to engrave wood. Once one has acquired the enormous skill needed to do a good watercolour sketch on paper, it can be done relatively fast. But putting burin to wood can never be done quickly, no matter how accomplished one be in the craft; it is slow, time-consuming work. And a good engraver has to be big enough to be pleased with small results.

Peter Stanley Smith was destined, you could almost say, to develop the gifts needed for xylography. Born in 1946 of Non-conformist Methodist parents and raised abstemiously in the North West of England, his maternal grandfather, a carder at Hollins Mill in Marple, Cheshire, drew trains for the young boy Peter on the large blackboard in his office, and gave him in 1952 as a five-year-old boy the responsibility to paint their house number '7' on the trash bin all by himself—no help or interference—because Peter wanted to be a draughtsman when he grew up. This serious event marked him for life. 'Peter, remember, you can't paint without paint on your brush.'

At age 11 Peter qualified for admission to the Hyde Grammar School for Boys. Because he was not being programmed for university, he was free to enjoy English and Art, and particularly Woodworking, at the school. The headmaster thought Peter's idea of going on afterwards to art school was 'romantic'. But for seven years the strict, friendly woodwork teacher at the school, a Mr Cousins, disciplined his young students in the craft and taught Peter a profound love for materials and for the tools to fashion the materials.

Mr Cousins died of cancer before the successful results of Peter's final exams were announced. Peter, who at age 15 had made profession of the christian faith during a Billy Graham Crusade in Manchester (1961), and who knew Mr Cousins had a Methodist background, went to visit him before he died. 'We will meet again, Peter,' Mr Cousins said. That remark was a sure signal of recognition, since you didn't wear your christian faith on your sleeve in an English Grammar School for Boys in those days. You just lived out the Non-conformist Methodist rigour and plodding gravity of life by requiring structured woodwork from rambunctious boys and by instilling in them somehow a deep sense of cherishing the comforting solid feel of good wood.

In 1965 Peter Smith left home to attend Birmingham Art School to become a graphic designer. After the required first year of training in diagnostic art and design during which he took an English course still needed—he was tutored weekends at home in Hyde by his fiancée, Carol Longden, who was studying Advanced Level English Literature at Astley Grammar School for Girls in Dukinfield—Peter's Birmingham tutor declared the received wisdom of Fine Art tutors of the day: 'If you do graphics, that is all you will be able to do. But if you do Fine Art, then, if you want to, you can still be a graphic designer.'

So from 1966 to 1969 Peter completed his BA degree in Fine Art (Painting) at Birmingham Art School. He met a large circle of young artists who became friends there—John Shakespeare, Ann Gall, Martin Rose, Jerry and Jackie Coleman, Paul Martin and Philip Miles, amongst others. They became a sounding board for Peter's encounter with convictions about life and work and death that greatly amplified the rather pietistic version of Methodism he had known.

John Shakespeare had discovered the writings of the historical Reformers, Luther and John Calvin, the English Puritans, and a new Dutch brand of Reformation philosophical thinking which had no truck with world-flight christianity but wanted to gird men and women for redemptive service in the regular

world of labour, politics, academics and art. So John Shakespeare arranged through the patronage of David Hanson, who was beginning his medical practice in London, to have this art history professor at the Free University of Amsterdam, Hans Rookmaaker (1922–77), a specialist in Gauguin's art, to come give a lecture at the Birmingham Art School.

Rookmaaker was a stump lecturer, popular in manner but thoroughly at home in art-historical detail and method à la Panofsky, with a disarming bluntness about his christian faith, whose hobby was Afro-American jazz, blues, spirituals, pop art and pop music. The Birmingham academic art historians present at the lecture were nonplussed: how can a matter-of-fact open Christian be an 'objective' scholarly authority on Gauguin and Gauguin's circle? And some of the 'Christian Fellowship' students present were disappointed that Rookmaaker didn't try to evangelize anyone or 'preach Christ' to the gathering. He just talked about powerful artworks, Utopianism, and the breakdown of Rationalism in modern art.

But for Peter Smith, John Shakespeare and friends, Rookmaaker's unabashed witness to how a sober, biblically christian faith can bring insight to art-historical matters—and ground art making as a responsible calling for those who are serious Christians and have the imaginative talent and determination to dedicate their work in love to God and neighbour—was most exciting. You don't have to design tracts for missionaries or confine yourself to constructing art for churches to be a 'christian' artist! You just need to love what you paint, sculpt, engrave, dance or write stories about in God's world, do it well and let your love breathe through the materials you form.

Rookmaaker was wont to prod and tease both unthinking Pilgrims on the narrow road and the cocksure Positivists fellow-travelling the broad road—so pointing to a 1600s painting in the Rijksmuseum of Amsterdam by Pieter Claeszoon, a 'still life' which captures the glory of pewter, broken glass, luscious fruit, a crust of bread and shining goblet of wine with the memento mori of a dead bug, he said, 'Now there's a christian painting!'

After graduating with his BA in Fine Art (Painting), Peter Smith married Carol Longden in August 1969 and headed to Manchester College of Art to do a one-year Postgraduate Certificate in Education. That year Peter arranged for Rookmaaker to come lecture at Manchester College of Art. Peter was now stimulated to read the Dutch Henk van Riessen's translated *Society of the Future* (1952), Schaeffer's *Pollution and the Death of Man: a Christian View of Ecology* (1970) and Rookmaaker's writings, especially 'Modern Art and Gnosticism' (1973).

There were so many ideas, trends, artistic styles and contemporary controversies to sort out! If you took Kandinski's paintings and book *Concerning the Spiritual in Art* (1912), which cribbed from Madame Blavatsky—Peter Smith made a study of this—what does it mean for doing art? Should the English landscape tradition updated by Ivon Hitchens (1893–1979), John Piper (1903–92) and Graham Sutherland (1903–86), which appealed to painter Peter Smith, be considered passé backwater because Abstract

Expressionism and Greenberg-induced Minimal Art of New York made-in-USA was the 1960s rage also in British art colleges? The visual language of nineteenth-century Courbet 'realism' or the diversionary tactics of the PreRaphaelite painters is not the way for forward-looking Christians busy with art to go if they want to be taken seriously in the postwar era of the Beatles, is it?

When Carol and Peter returned to the Midlands in 1970 for a tough job teaching Art at the large Frank F Harrison Comprehensive School in Walsall, where John Shakespeare was also teaching, 'the Birmingham Group' of artist friends continued regular interaction with Rookmaaker when he lectured in England. Rookmaaker's message for young artists was not prescriptive. His Reformational wisdom, however, had a definite thrust: (1) Renounce the Romantic notion (Shelley) that artists by definition are prophets who will herald, if not legislate, a brave new world; (2) deal imaginatively with the ordinary creatures around you—they have hidden glories; (3) make art that speaks to anybody rather than art enclosed within the jargon of a christian ghetto.

While the small group of Birmingham friends wrestled with the Calvinian/Kuyperian directives popularized by Rookmaaker, Peter Smith had become Corresponding Deacon for Midlands Road Strict (and Particular) Baptist Church. He also had his first two-man art show with Jerry Coleman at the E M Flint Gallery in Walsall. Peter taught Art full-time for two years at Frank F Harrison (1970–72), and then half-time for two years (1972–74).

The following position Peter Smith received (1974) was in nearby Dudley at Park Boys Secondary Modern School of 200 plus boys and 10 teachers. At the same time he began his Night paintings.

Rookmaaker always said, 'Paint what you know and love.' Peter became fascinated when driving the motorway around Birmingham at night: the dark attractive curve of the road, mysterious dots of light in the distance, temporary road signs covered prior to use, the dangerous comfort of being alone while driving. The paintings became glimpses of reality with which people could identify. Peter's Night paintings were popular in the 1975 exhibition 'From Birmingham', which he organized at the Free University of Amsterdam, on suggestion of Rookmaaker, for himself and painters Paul Martin, Martin and Kate Rose and Jerry Coleman, ceramist Jackie Coleman and jeweller David Secrett. Philip Miles designed the poster to advertise the event.

In 1977 Peter Smith was awarded the first Fine Art Fellowship provided by the Arts Council of Great Britain in the West Midlands area. The Fellowship was linked to the Dudley Education Services: two-thirds time in one's studio, one-third time spent working in schools. The Fellowship worked so well it was extended a second year, in which Peter had time to do etching and printmaking with Kim Kempshall, then Head of Printmaking at Birmingham Polytechnic. And it was in 1979 that Peter's interest in wood engraving was sparked, just about the time he accepted the post at Brooklands Technical College in Weybridge, Surrey, to set up a printmaking department for them. At this time also, Carol and Peter's family was beginning to come into the world: Zillah (1977), Alec James(1980) and Jacob (1983).

## The Quiet Voice of Peter Smith in Wood

Like many other wood engravers, Peter Smith is self-taught. Wood engraving has been largely neglected at Art Colleges in England for at least two generations.

Browsing in a bookshop in 1979 Peter came across Walter Chamberlain's *The Thames and Hudson Manual of Wood Engraving* (1978). He bought the book, sent off for four pieces of box wood and three tools, and made a start. His boyhood training in wood working stood him in good stead. The first engravings he did were hand burnished and later on printed on an 1846 Albion Press run by hand. His wood engraving *Leaving* (1984) was accepted for the open exhibit of the Society of Wood Engraving that year. So began his journey in this exacting, unpopular but modest, people-friendly artistry.

Coming to wood engraving as a painter, Peter Smith gives three-dimensional depth to his wood-engraved prints. There are frequently gentle curves in the composition that lead the viewer's eye back into the underground tunnel or past the foregrounded figure. The angle of the cut logs, the reflection of the teddy bear, the two rounded corners of the 'baptism' print itself, ensure that there is never just a silhouette but always an object in a background setting too. Such a compositional 'landscape' format is a trait found generically in the art of Bewick, Gwendolyn Raverat (1885–1957) and others, but quite unlike the bold frontal presence with which Blair Hughes-Stanton (1902–81) typically faces the viewer.

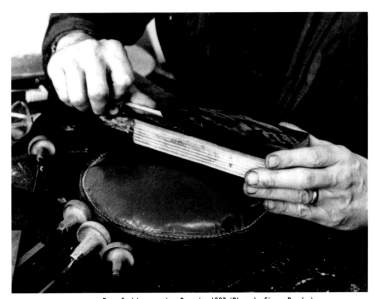

Peter Smith engraving *Remains*, 1992 (Photo by Simon Burder)

Peter Smith's centred objects are placed in confining spaces—a tub, a room, an underpass, a patch of ground. Human figures are seen from the back or in profile, and are entering, exiting or waiting soberly, patiently, for whatever is to come next. There is vivacity but no commotion. The bent figure in *Baptism* (1984) is deliberate, and the body under water is not struggling. The commuters leaving the Underground (1984) have rounded shoulders from the day's long work, too tired to jostle, just plodding forward. Even the etchings of the 1990s—*Winter Labels, Kew* or the nature morte named *Broken* (1992)—have a fixed, stationery stolid character, which is nevertheless expectant.

Peter Smith's earlier Night paintings (1974–80) probably underlie the darkness to his engravings of persons walking, waiting or working late, in dimly lit surroundings. The solitary dark figure in *Underground*

(1985) is neither ominous nor forlorn, just minding his business in the shadowy cavernous walkway of stairs. *Underpass* (1985) has three figures and an off-perpendicular black frame. The uncharacteristic engraving marks fleck the scene with soft friendly lighting, but the scene is dark enough for a person to be not too comfortable among strangers who are walking in step behind you. *Waiting* (1984) has the same ambiguity: there are no cross-hatching marks, but the greys gentle the environs, so the figure is not threatened but is poised, somewhat hesitant to move.

*Doorway* (1985) captures best, perhaps, the ambiguity of these darkling enigmas: the figure is not a stalker but is more of a flâneur in this rather uncertain architectural assemblage, facing the outdoors where there are trees, a light in the sky and other distant doorways to enter. In *Doorway* there are not the sharper, rather jagged and forbidding Existentialist shapes of Paul Nash (1889–1941). Peter Smith's darkness is not of crisis but is close here not to a brooding dilemma but to an enveloping suspense of mystery—maybe if the fellow steps out he will meet a doppelgänger as in a story by Charles Williams.

*Mr Punch* (1987) has a grin, a fancy collar, and a pleasant landscape behind his appearance, but most of Peter Smith's engravings are fairly sober. The dried out, cut-off plant stalks in *Winter at Kew* (1987) are not exactly headline news for the *Daily Mail*. But their group portrait is alive with wisps of light grasses, almost like earthy fireworks, showing the stalks they are not forgotten but in relief are being celebrated! The wood engraving *Seedling* (1992) and soft ground etching *Shoot* (1992) echo the same point: there can be light out of darkness, new life miraculously out of a dead stump of wood, a sprightly weak sprig in a flower pot next to large shards of discarded earthenware. It is a recurring leitmotif in Peter Smith's oeuvre: *Demolition* (1987) and *Remains* (1992) testify that what is left for refuse, the remnants of destructive human activity, have their own story to tell. Even Peter's 'abstract' etchings, which remind one roughly of Monica Poole's (1921–2003) fossil forms, are titled *Broken* (1992), *Discarded* (1992) and *Fragments* (1992). Leftovers are valuable too in his eyes; broken pieces reflect glints of light and reward attention that is not sentimental or morbid but simply inquisitive. Like those *Chapel Flowers* (1992) and etchings of ungainly clumped re-arrangements of spindly stems and blooms, they call to mind British poet Alice Meynell's lines in 'To a Daisy': *'O daisy mine, what will it be to look / From God's side even on such a simple thing?'*

*Working Late* (1986) is my favourite print and sums up for me the rich quality and humanly warm outreach of Peter Smith's wood engravings. His *schlicht* style, as you would say in German, his 'unpretentious' low-key style has a strict and particular austerity to its horizontal-vertical boxed regularity of a frame, yet there is gentleness in the markings of so many different sorts. The barred window through which we look into the room where the seated figure is bent earnestly over his work at the large desk is not a barrier, but is softly inviting us to take a closer look. Artist Peter Smith uses the intimacy of the wood engraving medium to tell us without words that we are entering a retreat, a simple place of studied quiet. Working late is not waiting for Godot but is being faithful in one's assigned service.

I would describe the spirit that breathes through all of Peter Smith's wood engravings, etchings and drawings, as a spirit of chaste, quiet wonderment. There is no place in his artwork for the provocative

or querulous, the sensational or sophisticatedly parodic. There is a sense of traditional order that is not old-fashioned but that is reliable. There is modesty in Peter Smith's artistry, a winsome homeliness that half-knows you are really courageous when you are fearful but carry on doing what is needed. He has the copious imaginativity to see not 'sermons in stones' nor 'a World in a Grain of Sand' but a well-tempered sound of steady, arresting hopefulness in whatever transpires around us. I find intimations of quieting peace in the artwork: no jubilation, no laments, but a strong trusting expectation that all our troubles and uncertainties will not end in melancholy but may anticipate *Light in the Garden* (1994) we tend.

In 1983 Peter Smith became Head of Art at Kingston College in Surrey. Under the new Principal, Arthur Cotterell (in charge, 1984–2005), Peter was encouraged to expand the Art programme so that when the College moved certain courses to new quarters in 1995, the fine old Edwardian building was free to become the new base for Art and Design, which has become Kingston College's School of Art, now with some 40 staff and over 500 students. Peter Smith's managerial talents and time are taxed to the limit. He was still able to achieve a post-graduate MA diploma in printmaking (1989–92) at Wimbledon Art School working with Brian Perrin, and also stone lithographer Simon Burder, with Jane Joseph as personal tutor. And wood engraving?

After the great storm of 16 October 1987 Peter went to draw the mayhem of uprooted trees and destroyed vegetation in Richmond Park. A large charcoal drawing he did of the destruction was shown in his one-man show at Alba Fine Art Gallery in Kew, 1988. Seasoned wood engraver Edwina Ellis (b.1946) saw the drawing, bought it, and talked with Peter who said he was engraving the piece too. Edwina had been commissioned by the Society of Wood Engravers, with four others—George Tute, Peter Reddick, Claire Dolby and Monica Poole—to do a folio edition of prints as a memorial for the devastation of England's trees. In an act of pure-hearted generosity Edwina Ellis was able to give her commissioned spot to Peter Smith. Making good on Edwina's great gift Peter's stunning *Fallen Tree* (1989) is the result.

*Fallen Tree* lets us see close up a chunk of the massive trunk of a magnificent tree, now resting in peace gently on the impacted ground, cleanly cut through by a chainsaw. A bit of sky and a brush of trees fill the upper background, and a few twisted twigs in the narrow foreground dance at the death of this huge, heavy wonderful creature. The age-old bark is honoured with various intricate engraved patterns, shining almost like the ribbons on chests of war veterans. And the two mighty sections of trunk kiss discretely across a hairs-breadth chasm of air backlit by wondrous light. We see the stillness after the storm. *Fallen Tree* is a requiem. A tree as impressive as the cedars of Lebanon, the Psalmist would say, has been broken by the sevenfold voice of the LORD God (Psalm 29:5). And it is terrible. So be quiet and awed, little man and woman. Even mighty trees, which usually live longer than we humans, can become fallen. And then we who survive are bereft, as Gerald Manley Hopkins phrased it: '*What would the world be, once bereft / Of wet and of wildness? Let there be left, / O let there be left, wildness and wet; / Long live the weeds and the*

*wildness yet.'* In a very orderly way Peter Smith's *Fallen Tree* echoes the deep-seated wish of many for the great trees of England and the wildness to be left yet.

In 2004 Peter received a commission from Tate Britain to engrave a 4"x 4" wood block of a flower that could accompany a small side-gallery exhibit of Victorian illustrations engraved by the Dalziel brothers. In line with their educational policy, curator Heather Birchall of Tate Britain and Sarah Hyde, Head of Interpretation, wanted a set of proofs and the actual wood block for people to touch, handle and examine, to get a sense of the incredible skill needed in the wood engraving process. Peter's lovely animated *Peperomia* (2004) met the public block-in-hand at the Tate for a whole year. It was a wonderful way for him to carry on concretely the vision of Pieter Claeszoon bespoken earlier by Rookmaaker.

The artistry of wood engraving is not an endangered species so long as a community of painstaking, skilled imaginative artists like Peter Stanley Smith take the time—can find time!—much time, to engrave wood for neighbours to give them eyes to see and ears to hear with quiet wonderment the marvels hidden and waiting to be discovered in ordinary things and daily occurrences. This book in your hands too, *The Way I See It*, wishes to add its voice to the promise of continuing the joy of engraving wood.

Finally, I have a suggestion for readers and viewers of this book: Consider the collection of wood-engraved prints in your lap to be something comparable to an ancient Book of Hours. It is not meant to encourage you to pray 'Ave, Maria', and does not pretend to point morals or be a block-booked 'Gideon Bible' of sorts. But the sense of wood engraving in our day is to give those who are inundated by noise and pushed silly by routine and deadlines, weary of the pell-mell speed and incessant din hemming us in, a respite, a pause for reflecting thankfully on our being dated and located human creatures. It would be a mistake to hurry through these pages. Better, take time. Give these wood engravings and their quiet voice time to speak and to be heard, since at our backs too is 'Time's winged chariot hurrying near.'

Perhaps you could treat these art prints like a contemporary Emblem book and fill out their captions with a personal phrase of your own—relish the image and later return to your earlier thought to see whether your response has changed, matured. To respond in written words to a graphic image is to forge a community across boundaries of place and time and medium. It fosters a listening intimacy, a matter almost built into good wood engraving, a gift of scarce shalom.

## Selected Background Sources

Ainslie, Patricia & Paul Ritscher. Introductory essays. In *Endgrain: Contemporary Wood Engravings in North America*. Mission, British Columbia: Barbarian Press, 1994/1995

Barstow, Kurt. *The Gualenghi-d'Este Hours: Art and Devotion in Renaissance Ferrara*. Los Angeles: The J Paul Getty Museum, 2000

Brett, Simon. *An Engraver's Globe: Wood Engraving World-wide in the Twenty-first Century*. London: Primrose Hill Press, 2002
—. *Engravers: A Handbook for the Nineties*. Compiled for the Society of Wood Engravers, with an introduction. Swavesey, Cambridge: Silent Books, 1987
—. *Engravers Two*. A handbook compiled for the Society of Wood Engravers. Swavesey, Cambridge: Silent Books, 1992
—. 'Wood Engraving.' In Archie Miles, *Silva: The Tree in Britain*. London: Ebury Press, 1999, pp316–25

Chamberlain, Walter. *The Thames and Hudson Manual of Wood Engraving*. London: Thames and Hudson, 1978

Farleigh, John. *Graven Image: An Autobiographical Textbook*. London: Macmillan & Co., Ltd., 1940

Garrett, Albert. *A History of Wood Engraving*. London: Bloomsbury Books, 1978

Hamilton, James. *Wood Engraving & the Woodcut in Britain c.1890–1990*. London: Barrie & Jenkins, 1994

Harbison, Craig. 'Introduction to the Exhibition', printed with an earlier lecture delivered by Erwin Panofsky, 'Comments on Art and Reformation' (1960). In *Symbols in Transformation. Iconographic Themes at the Time of the Reformation: An Exhibition of prints in memory of Erwin Panofsky*. Princeton: The Art Museum, Princeton University, 1969

Jaffe, Patricia. 'Taken by Storm.' *The National Trust Magazine*, no. 69 (Spring 1990), pp37–38

Lindley, Kenneth. *The Woodblock Engravers*. Newton Abbot: David & Charles, 1970

Moxey, Keith. *Peasants, Warriors and Wives: Popular Imagery in the Reformation*. London: University of Chicago Press, 1989

Rookmaaker, Hans R. *The Complete Works of Hans R. Rookmaaker*, 6 volumes, edited by Marleen-Hengelaar-Rookmaaker. Carlisle: Piquant, 2002–03

Seerveld, Calvin. 'God's ordinance for artistry and Hogarth's "wanton chace".' In *Marginal Resistance: Essays dedicated to John C. Vander Stelt*, ed. John Kok. Sioux Center: Dordt College Press, 2001, pp311–36
—. 'Telltale Statues in Watteau's Paintings.' *Eighteenth-Century Studies*, 14:2 (Winter 1980-81), pp151–80

Selborne, Joanna. *British Wood-Engraved Book Illustration 1904–1940: A Break with Tradition*. Oxford: Clarendon Press, 1998

Wieck, Roger S. *Painted Prayers: The Book of Hours in Medieval and Renaissance Art*. New York: George Braziller, Inc., with the Pierpont Morgan Library, 1997

*Many conversations and lengthy correspondence with artist Peter S Smith*

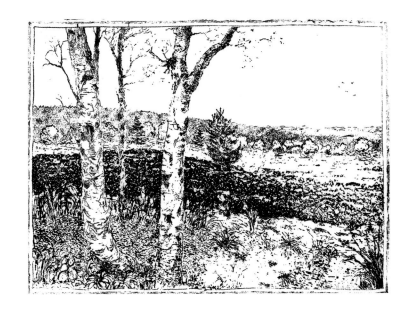

**Cannock Chase**
Etching 1972 (72mm x 102mm)

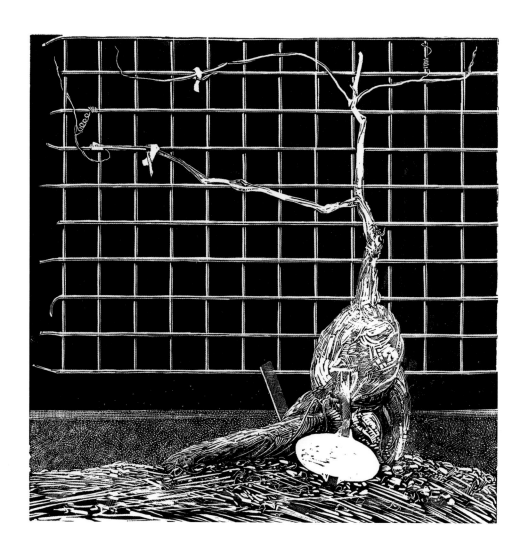

**Birmingham Botanical Gardens**
Wood Engraving 1979 (128mm x 128mm)

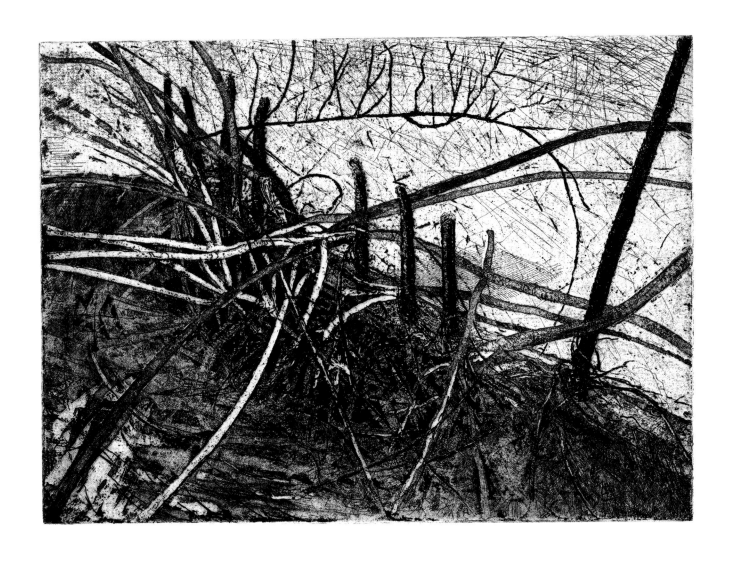

**Broken Fence**
Etching with Aquatint 1979 (160mm x 222mm)

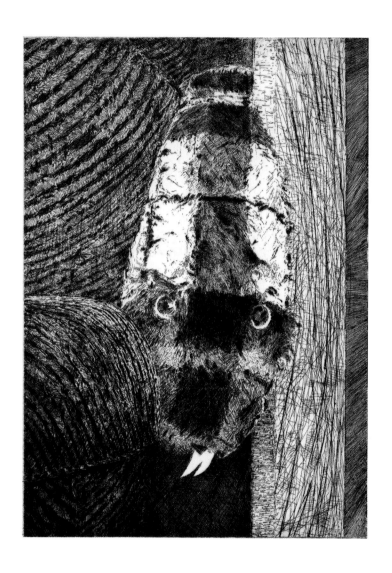

**Snake**
Etching 1980 (132mm x 96mm)

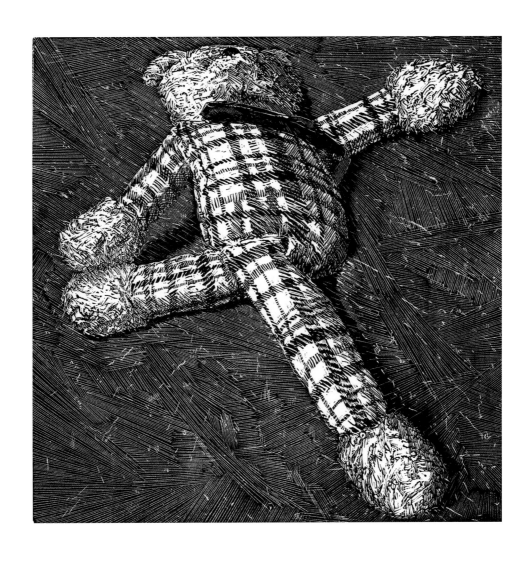

**Bear**
Wood Engraving 1980 (132mm x 129mm)

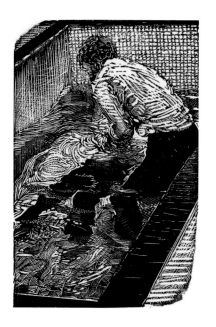

**Baptism**
Wood Engraving 1984 (76mm x 51mm)

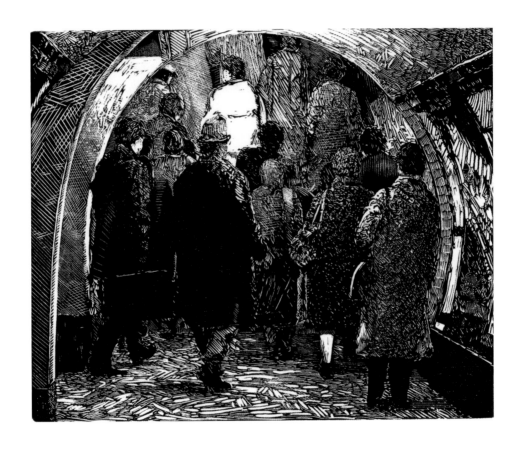

**Leaving**
Wood Engraving 1984 (103mm x 127mm)

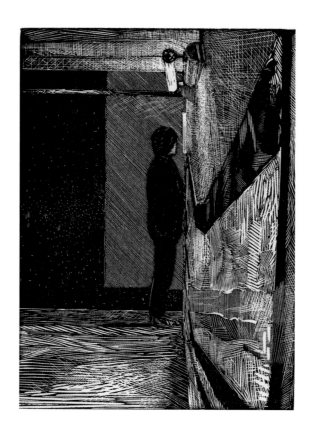

**Waiting**
Wood Engraving 1984 (101mm x 76mm)

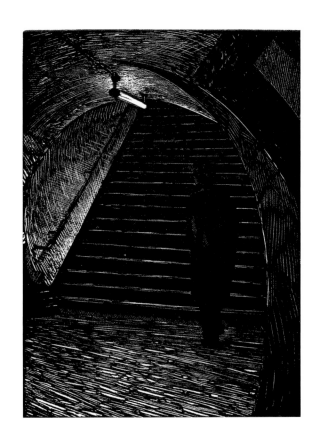

**Underground**
Wood Engraving 1985 (102mm x 77mm)

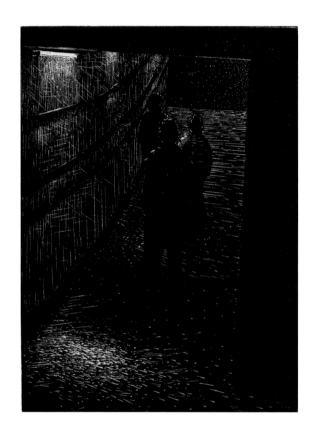

**Underpass**
Wood Engraving 1985 (102mm x 77mm)

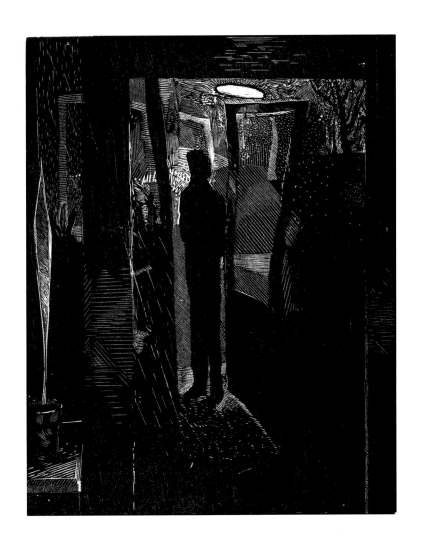

**Doorway**
Wood Engraving 1985 (127mm x 102mm)

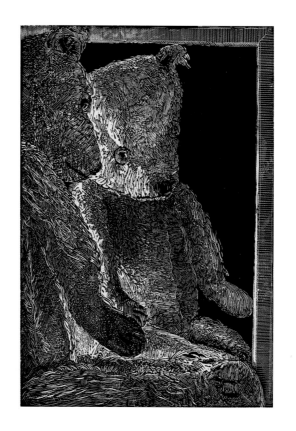

**Douglas**
Wood Engraving 1986 (102mm x 70mm)

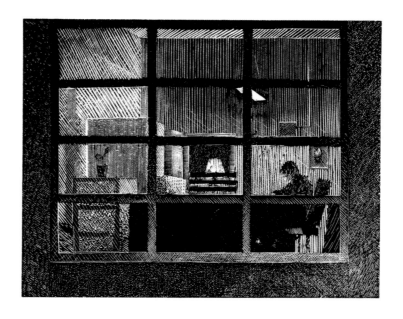

**Working Late**
Wood Engraving 1986 (76mm x 102mm)

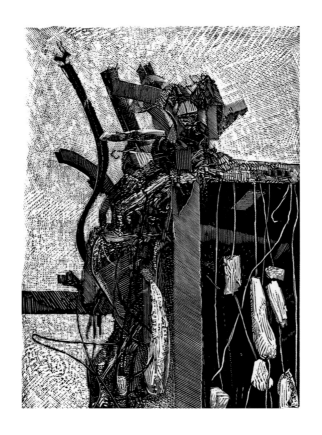

**Demolition**
Wood Engraving 1987 (105mm x 77mm)

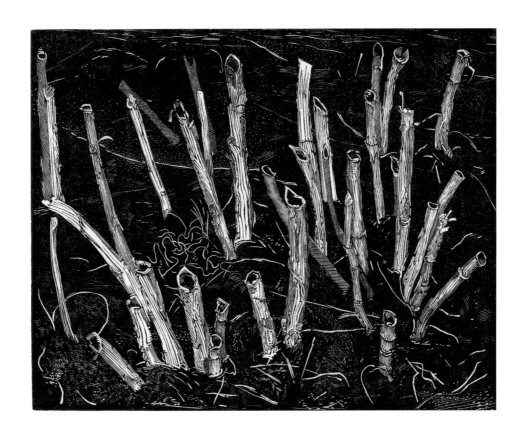

**Winter at Kew**
Wood Engraving 1987 (100mm x 127mm)

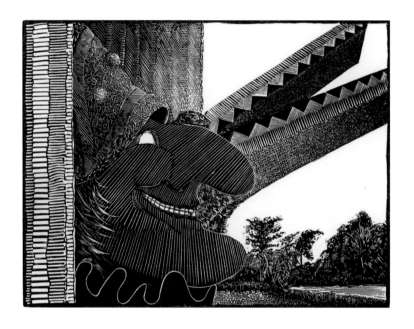

**Mr Punch**
Wood Engraving 1987 (77mm x 102mm)

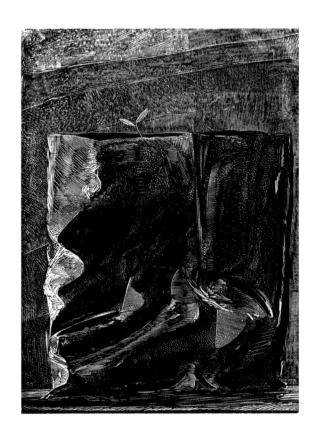

**Seedling**
Wood Engraving 1988 (102mm x 77mm)

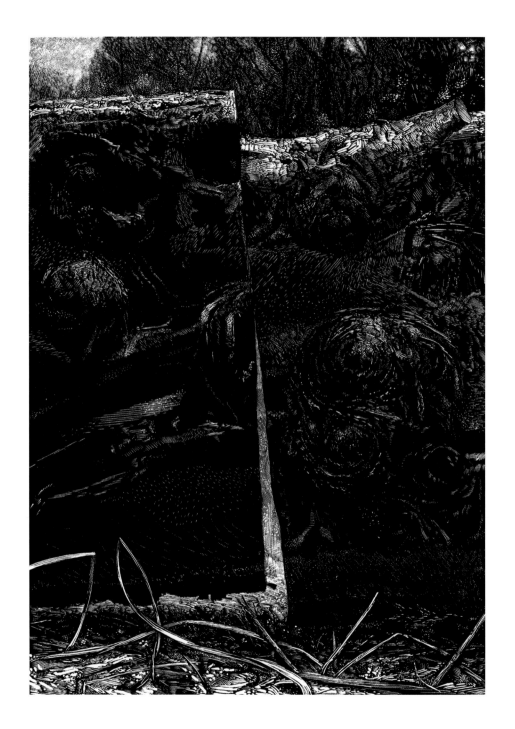

**Fallen Tree**
Wood Engraving 1989 (174mm x 126mm)

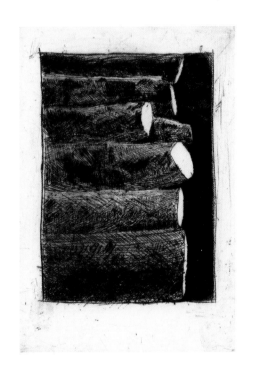

**Log Pile**
Drypoint 1989 (86mm x 60mm)

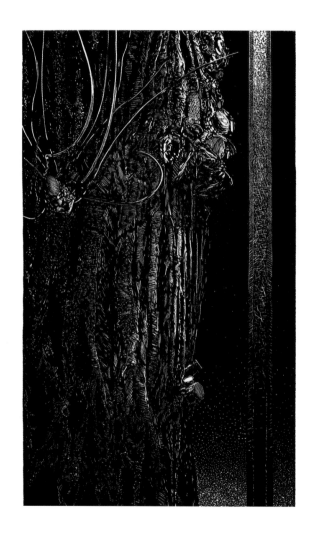

**SW 19**
Wood Engraving 1990 (130mm x 75mm)

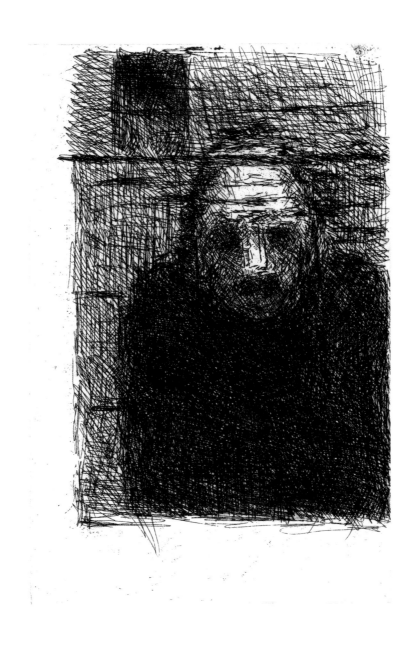

**Reflection**
Etching 1990 (148mm x 100mm)

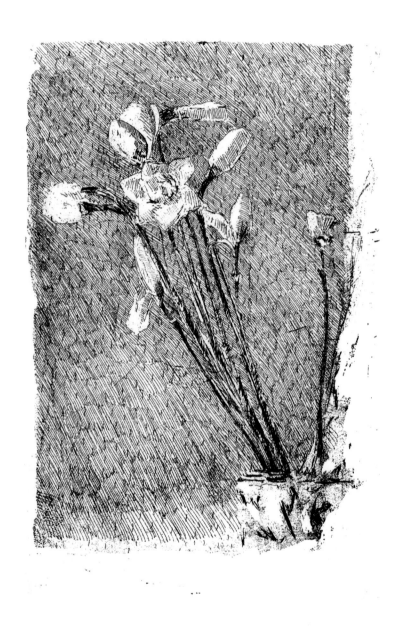

**Chapel Flowers**
Etching 1990 (152mm x 100mm)

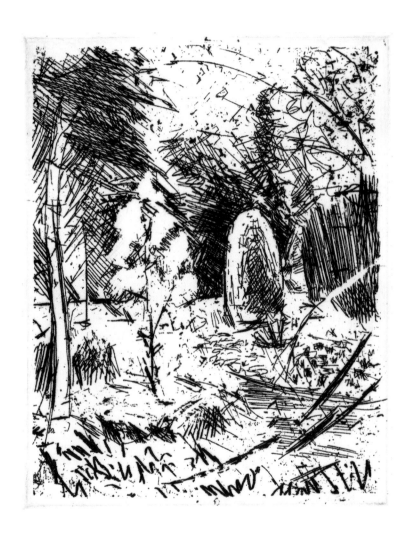

**Glimpse of the Garden**
Etching 1990 (124mm x 100mm)

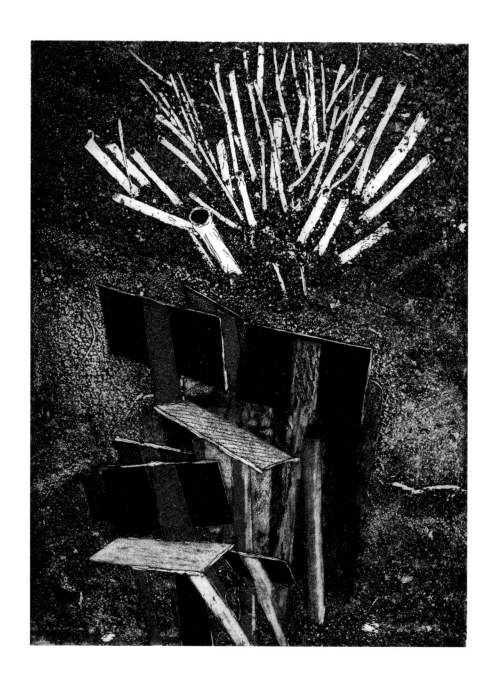

**Labels and Stalks**
Etching and Aquatint 1991 (162mm x 123mm)

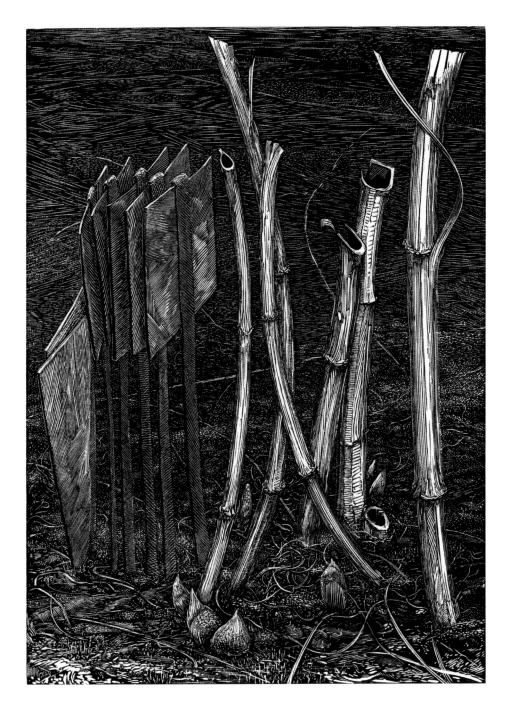

**Winter Labels, Kew**
Wood Engraving 1991 (174mm x 126mm)

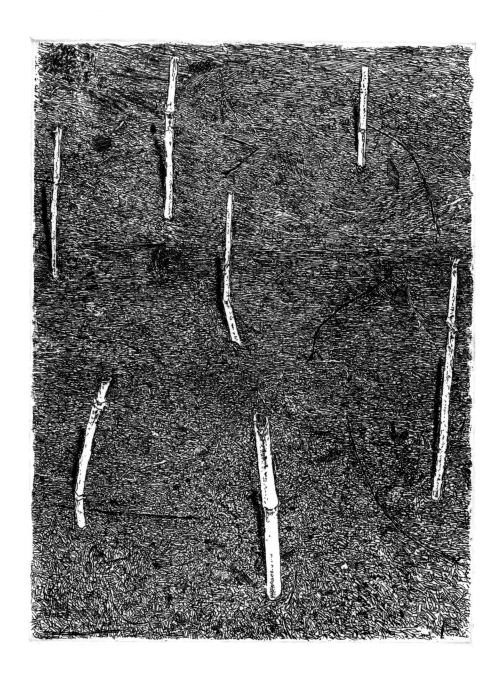

**White Stalks**
Etching 1991 (161mm x 124mm)

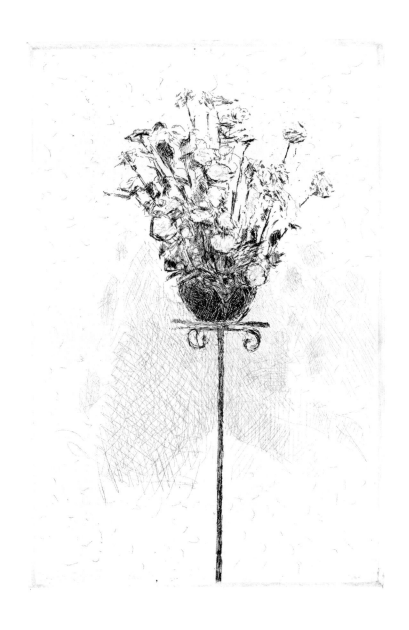

**Fragile Arrangement**
Etching 1991 (98mm x 150mm)

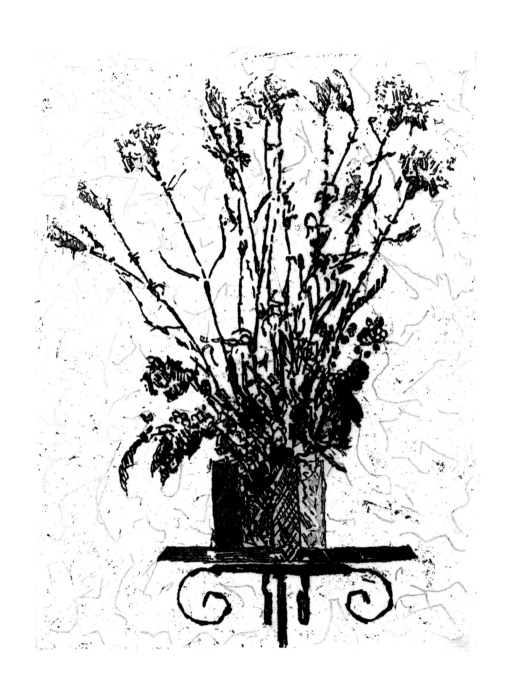

**Flowers**
Soft Ground Etching 1991 (161mm x 125mm)

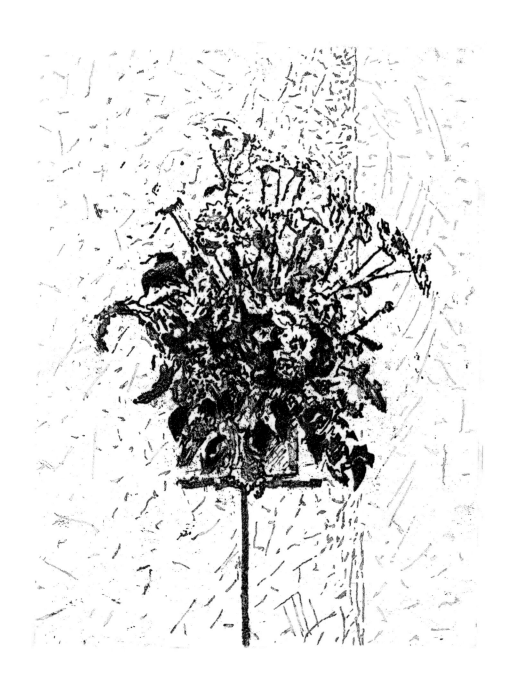

**Flowers in a Corner**
Soft Ground Etching 1991 (161mm x 125mm)

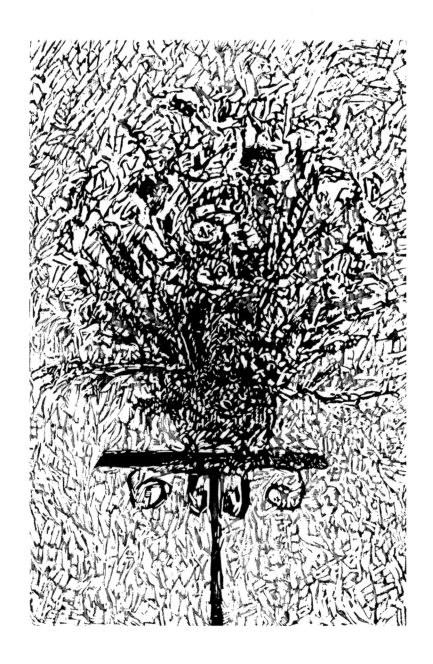

**Re-Arrangement**
Plastic Engraving 1991 (155mm x 102mm)

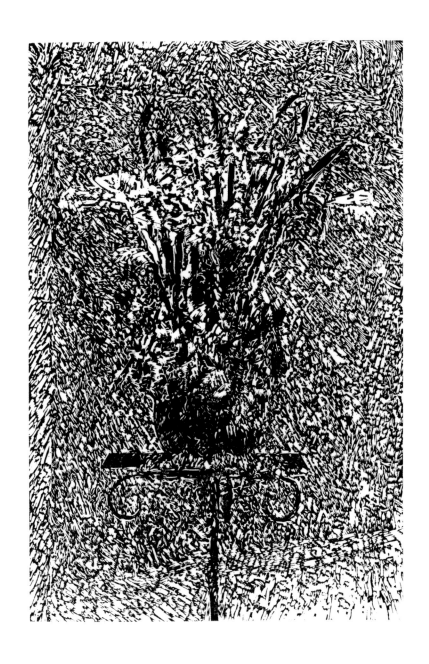

**Cut Flowers**
Plastic Engraving 1991 (154mm x 101mm)

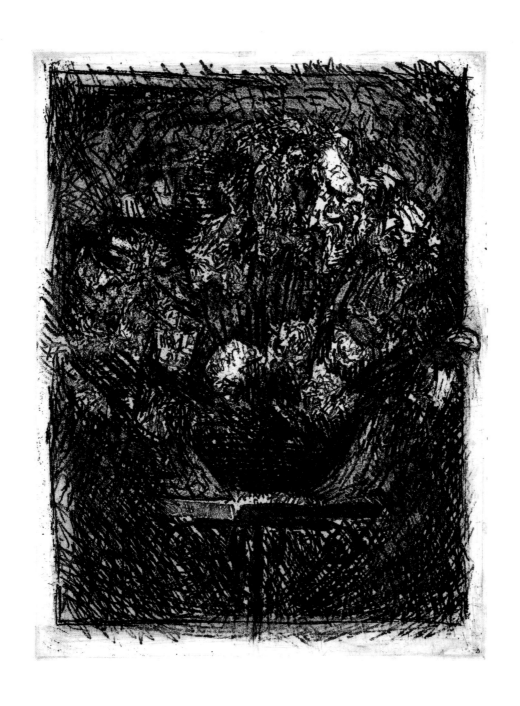

**Flowers in a Dark Place**
Soft Ground Etching 1991 (Two plates; 162mm x 125mm)

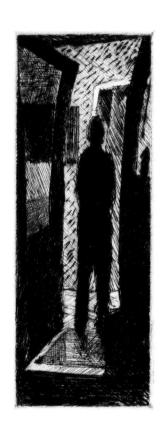

**Doorways**
Drypoint 1992 (98mm x 36mm)

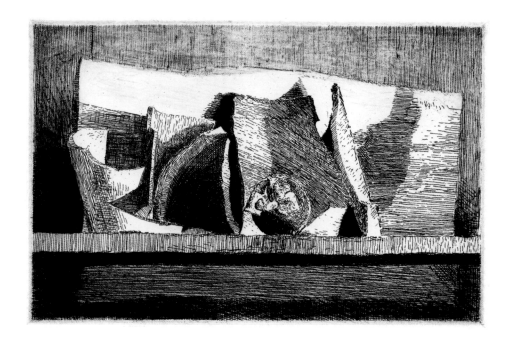

**Discarded**
Etching 1992 (80mm x 128mm)

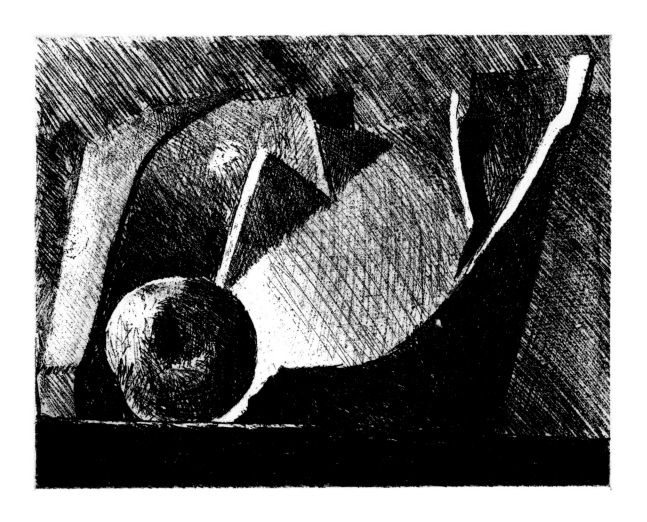

**Broken**
Soft Ground Etching 1992 (122mm x 161mm)

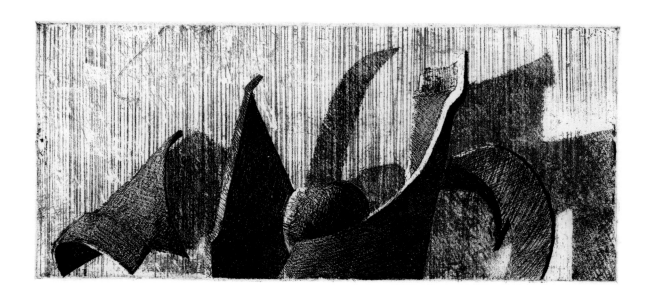

**Fragments**
Soft Ground Etching 1992 (105mm x 247mm)

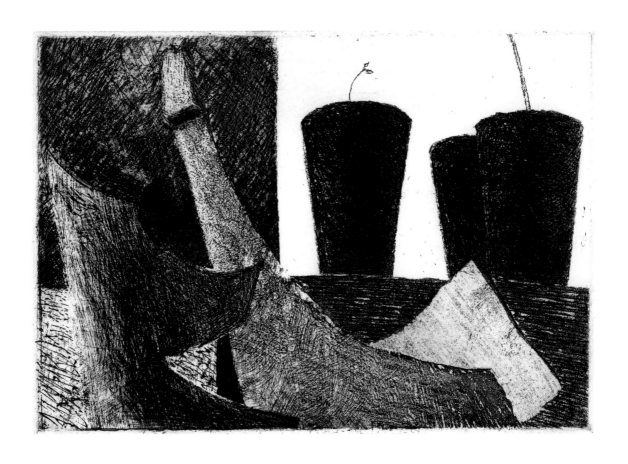

**Shoot**
Soft Ground Etching 1992 (105mm x 152mm)

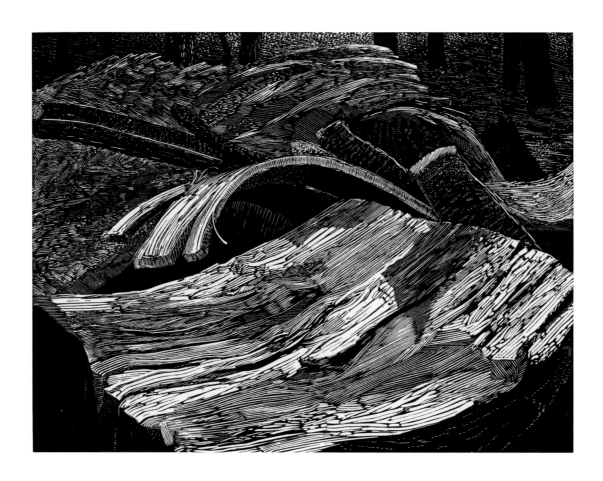

**Remains**
Plastic Engraving 1992 (112mm x 148mm)

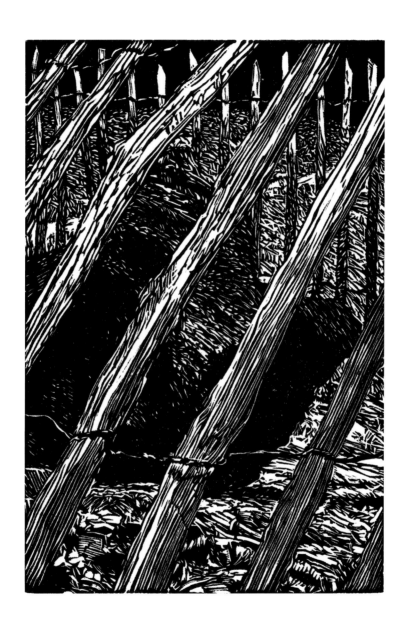

**Burnt Log**
Lino Cut 1992 (150mm x 102mm)

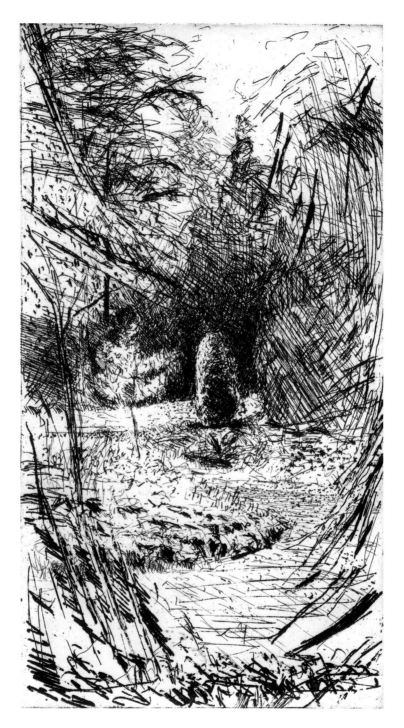

**Heather—Kew**
Etching 1992 (Two plates; 180mm x 100mm)

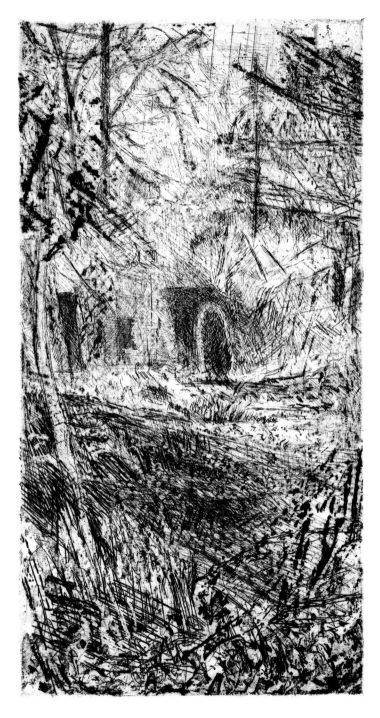

**Garden**
Etching 1992 (180mm x 95mm)

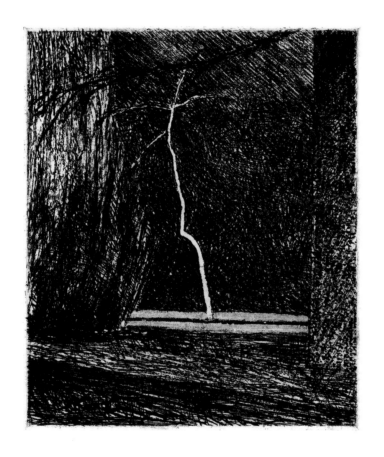

**Light in the Garden**
Etching 1994 (105mm x 90mm)

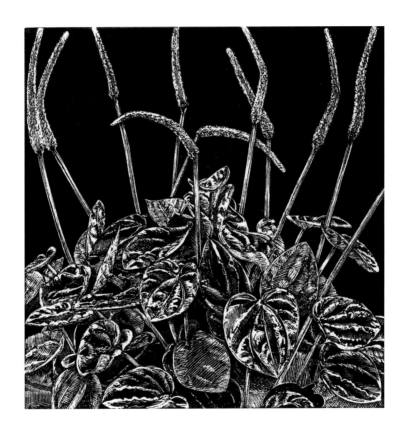

**Peperomia**
Wood Engraving 2004 (101mm x 99mm)

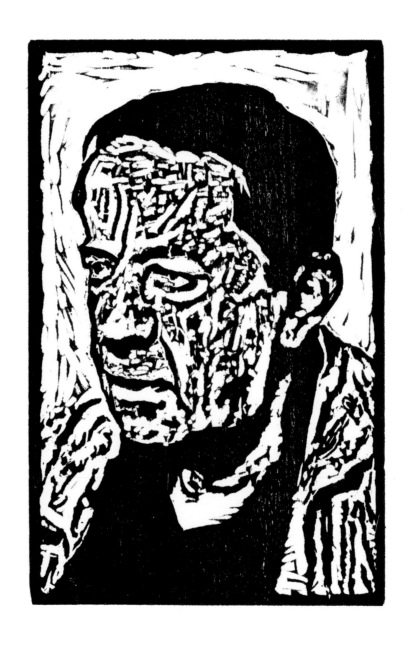

**Cal—Athens**

Woodcut 2006 (150mm x 100mm)

# Peter S Smith

b. 17 September 1946, Marple in Cheshire, England

## Academic

| | |
|---|---|
| 1969 | Birmingham Polytechnic: BA (Fine Art) |
| 1970 | Manchester Polytechnic: PGCE |
| 1977–79 | West Midlands Arts Fine Art Fellow |
| 1992 | Wimbledon School of Art: MA (Printmaking) |

## One Person Exhibitions

| | |
|---|---|
| 1973 | Birmingham University |
| 1974 | Sheffield College of Art |
| 1977–79 | Dudley Art Gallery |
| 1978 | Cannon Hill Arts Centre, Birmingham |
| 1979 | West Midlands Arts Travelling Exhibition |
| 1985 | 'Wood Engravings' at Birmingham Polytechnic and Dudley Art Gallery |
| 1988 | Alba Fine Art, Kew |
| 1991 | Arts Centre Group, London |
| 1999 | Penny School Gallery, Kingston |

## Selected Mixed Exhibitions

| | |
|---|---|
| 1974 | Jerry Coleman and Peter Smith at the E M Flint Gallery, Walsall |
| 1975 | 'From Birmingham' at the Free University, Amsterdam |
| 1976/77 | 'The Figurative Approach' at Fischer Fine Art, London |
| 1977 | 'Midlands Art Now' at Ikon Gallery, Birmingham |
| 1974–88 | Summer Exhibitions at the Royal Academy of Arts, London |
| 1982 | Kim Kempshall, John Geldhill and Peter Smith at Oriel 700, Aberystwyth |
| 1983/84 | Piccadilly Gallery, London |
| 1984–92 | Society of Wood Engravers Annual Exhibitions |
| 1986 | William Curtis Gallery, Perth Australia |
| 1987 | 50th Retrospective Exhibition of the Society of Wood Engravers |
| 1989 | 'Three Wood Engravers' at Halifax House, Oxford 2005 |
| 1990 | 'Broad Horizon' at Agnew's, London |
| 1991/92 | Wimbledon School of Art (WSA) Postgraduate Printmaking at Morley Gallery, London |
| 1993 | The Open Eye Gallery, Edinburgh |
| 1994 | The Pryzmat Gallery, Krakow, Poland. Prints from WSA |
| 1995 | 'Word and Image' at Calvin College, Michigan, USA |
| | Hochschule Für Kunste Gallery, Bremen, Germany. Prints from WSA |

| 1996 | National College for Art and Design, Oslo, Norway. Prints from WSA |
|------|-------------------------------------------------------------------|
| 1997 | The Library Gallery, Wimbledon. Prints from WSA |
|      | Morandi Museum , Bologna, Italy. Prints from WSA |
| 1997–2004 | Mixed Exhibitions at the Penny School Gallery, Kingston |
| 1998 | 'Five Printmakers' at the Penny School Gallery, Kingston |
| 1999 | 'FAB3' at the The Stanley Picker Gallery, Kingston University |
| 2000 | 'Rentreé' at the The Stanley Picker Gallery, Kingston University |
| 2001 | 'FAB4' at the The Stanley Picker Gallery, Kingston University |
| 2004 | Andre Demedtshuis, Sint–Baafs–Vijve, Belgium |
| 2005 | 'FAB6' at the The Stanley Picker Gallery, Kingston University |

## Commissions & Collections

Society of Wood Engravers: 'The Great Storm' boxed set, 1989
Engraving to celebrate the 100th Anniversary of Wimbledon School of Art (1890–1990)
Tate Britain: Wood engraving and block to go with Dalziel Bros. Exhibition, 2004
Kingston College: Set of six paintings to record views from Kingston College, 1994/2005

Collections include:
West Midlands Arts; Dudley Art Gallery; Dudley Education Services; Herefordshire College of Art and Design; Kingston College; Kingston University; Victoria and Albert Museum; Print Room, Royal Collection, Windsor; Tate Britain; Free University, Amsterdam; Glenbow Museum, Calgary, Alberta, Canada; Calvin College, Michigan, USA

## Publications

'Art Workshop Notes.' *International Reformed Bulletin* 80, 1981
'Rembrandt—a Style of Grace.' Book Review in *Third Way*, August 1983
'Peter Fuller—the Naked Critic.' *Third Way*, April 1984
'The Pre-Raphaelites.' Exhibition Review in *Third Way*, April 1984
'Making Paintings.' In Tim Dean and David Porter (ed), *Art in Question: London Lectures in Contemporary Christianity 1984* (Basingstoke: Marshall Pickering, 1987) ch 6
'British Art in the 20th Century.' Book Review in *Third Way*, March 1987
'Why I like it – a Print by Philip Hagreen.' *Multiples*, 15 March 1989
'The Wood Engravings of Gwen Raverat.' Book Review in *Multiples*, 20 January 1990
'Perceptions of Landscape.' Book Review in *Third Way*, October 1992
'The Complete Works of Hans Rookmaaker, vols 1 and 2.' Book Review in *AM Artsmedia Journal* 3, 2002
'The Complete Works of Hans Rookmaaker, vols 3 and 4.' Book Review in *AM Artsmedia Journal* 6, 2003

Work by Peter S Smith has been reproduced in the following publications:

Richard Wurmbrand. *From the Lips of Children.* Hodder and Stoughton, 1986

M Hengelaar-Rookmaaker, *The Complete Works of Hans Rookmaaker 6.* Carlisle: Piquant, 2002–03

Simon Brett (ed). *Engravers: a Handbook for the Nineties.* Cambridge: Silent Books, 1987

*A Cross Section: The Society of Woodengravers 1988.* Wakefield: The Fleece Press, 1988

Patricia Jaffe. 'Taken by Storm.' *The National Trust Magazine 90*, Spring 1990, pp37–38

W E and D J Butler (ed). *Modern British Bookplates.* Cambridge: Silent Books, 1990

Simon Brett (ed). *Engravers* 2. Cambridge: Silent Books, 1992

Simon Brett. 'More British Wood Engravers'. *Watercolours, Drawings and Prints* 2:2, April 1992, p31

*Words and Images.* Exhibition Catalogue.  Calvin College Art Center Gallery, Grand Rapids, Michigan, 1995

*Fab.3.* Exhibition Catalogue. Kingston University, Kingston upon Thames, 1999

Archie Miles. *Silva: The Tree in Britain.* London: Edbury Press, 1999, p319

*Fab.4.* Exhibition Catalogue. Kingston University, Kingston upon Thames, 2001

## Vocational

| | |
|---|---|
| 1983– | Head of School: Art, Design and Media, Kingston College |
| 1986 | Elected Member of the Society of Wood Engravers |
| 2002–05 | Annual workshops at Christian Artists Seminar, Doorn in the Netherlands |
| 2003– | UK Board Member of the European Academy for Culture and Art (EACA) |
| 2006– | 2nd Vice-President of the National Society for Education in Art and Design (NSEAD) |

**Last Slide Show (Portrait of Glynn Williams)**
Wood Engraving 1990 (40mm x 40mm)

# List of Images

VISIBILIA series, no. 1
This first edition, limited printrun of 1000 copies,
copyright © 2006 by Piquant Editions Ltd.
PO Box 83, Carlisle, CA3 9GR, UK
www.piquanteditions.com

**British Library Cataloguing in Publication Data**

Smith, Peter S.
 The way I see it : wood engravings and etchings by Peter S.
Smith. - (Visibilia series ; no. 1)
 1.Smith, Peter S.
 I.Title
 761.2'092

 ISBN-13: 9781903689202
 ISBN-10: 1903689201

Design: Jonathan Kearney
Cover image: *Doorway* (1985) by Peter S Smith
Printed in Thailand